Art of Africa

Ndebele Designs to Color

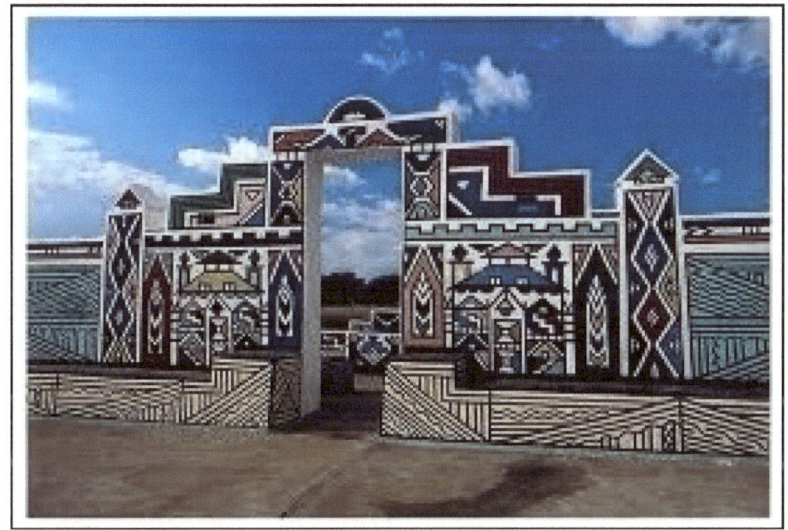

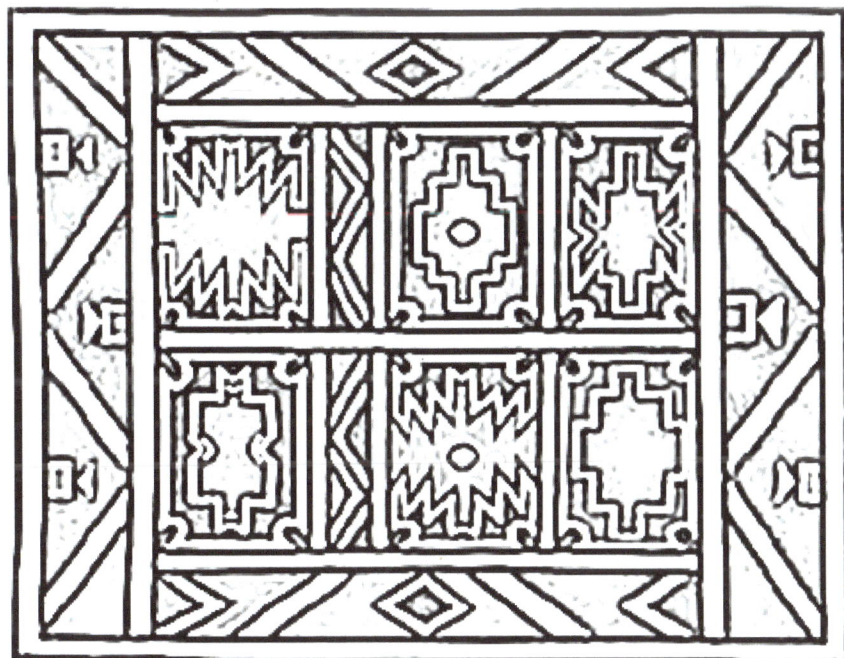

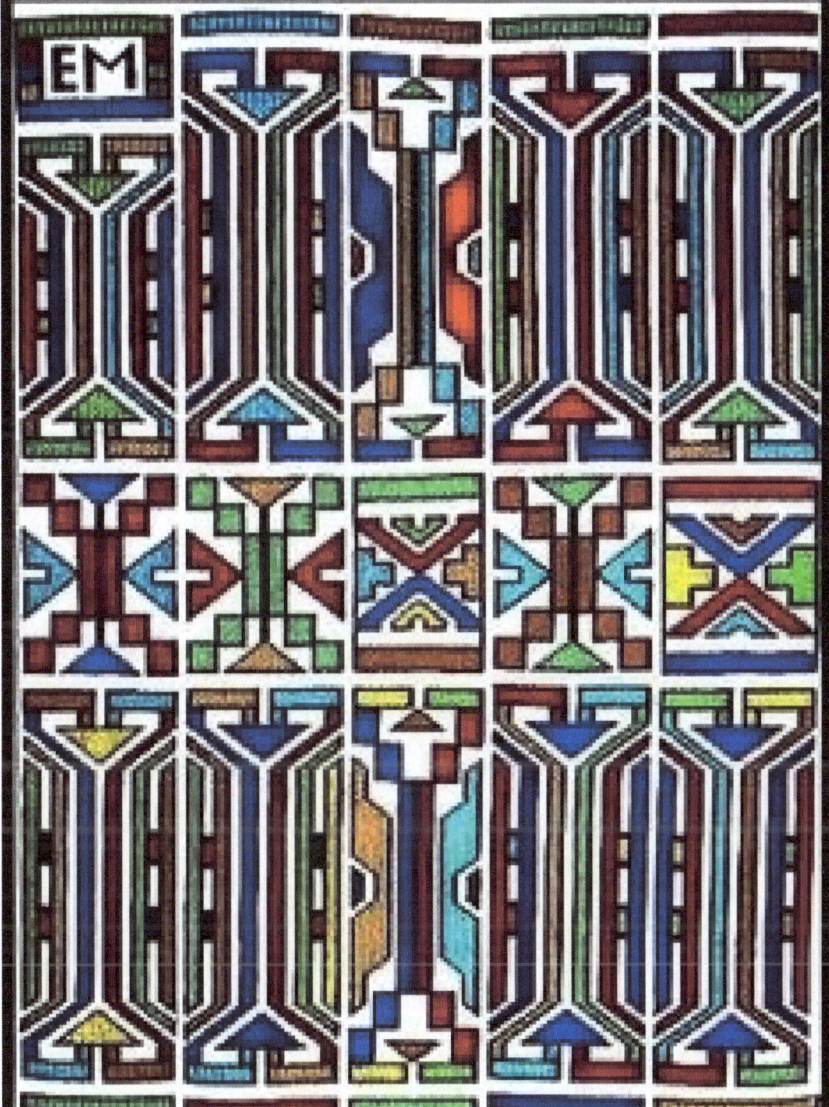

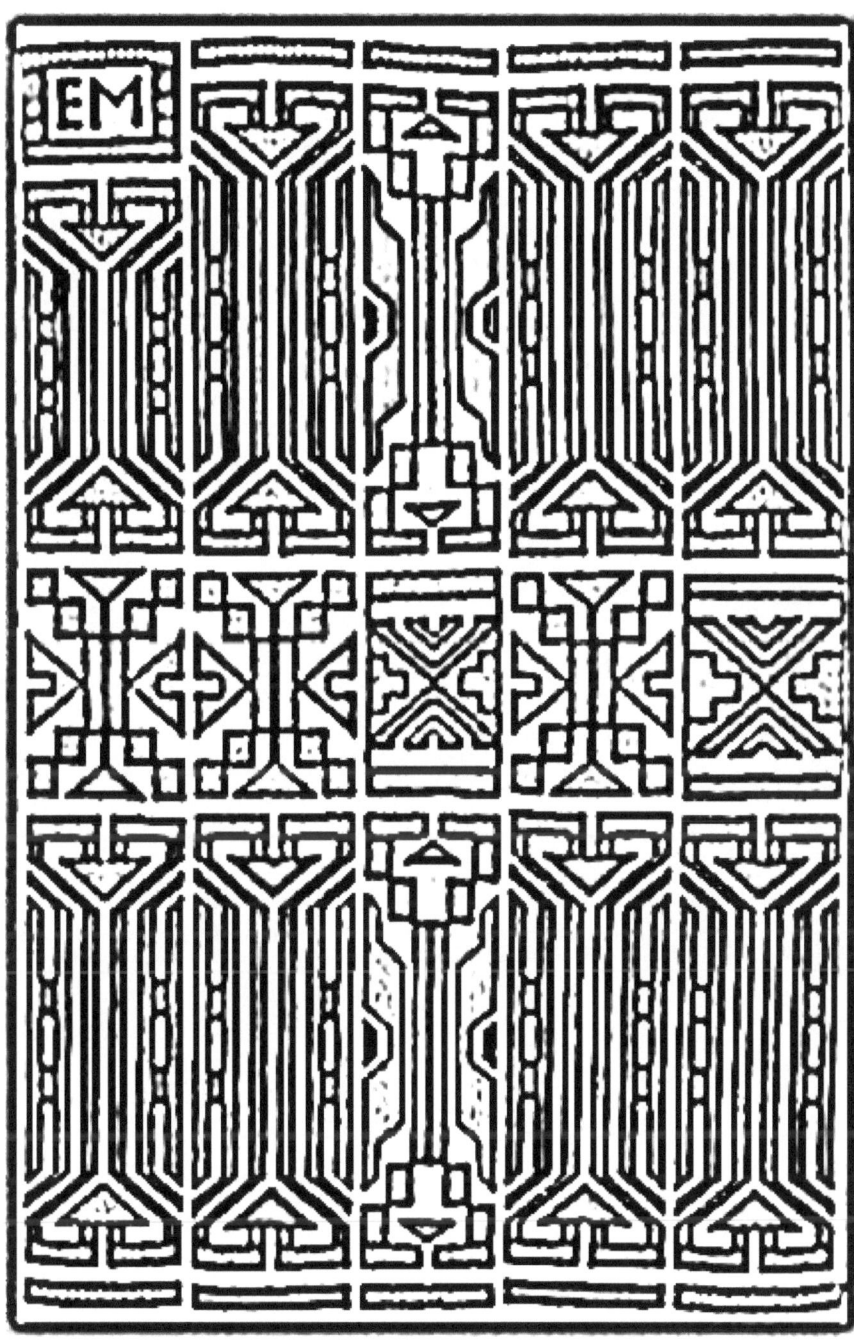

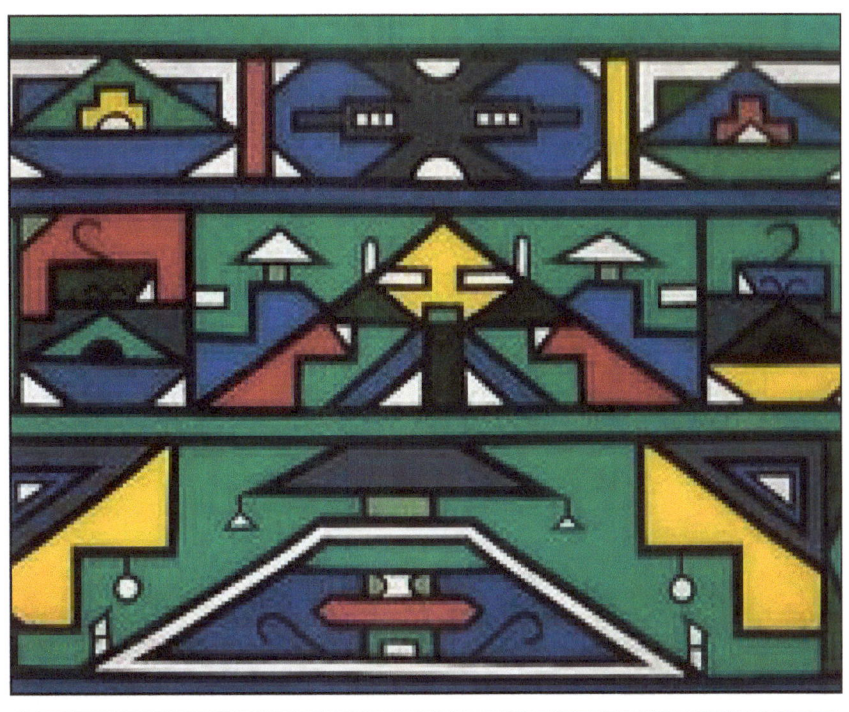
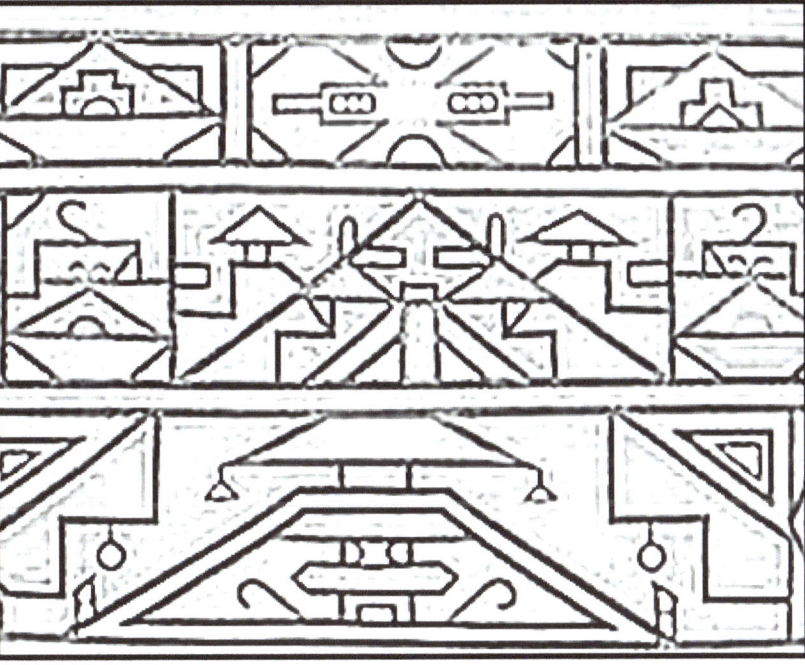

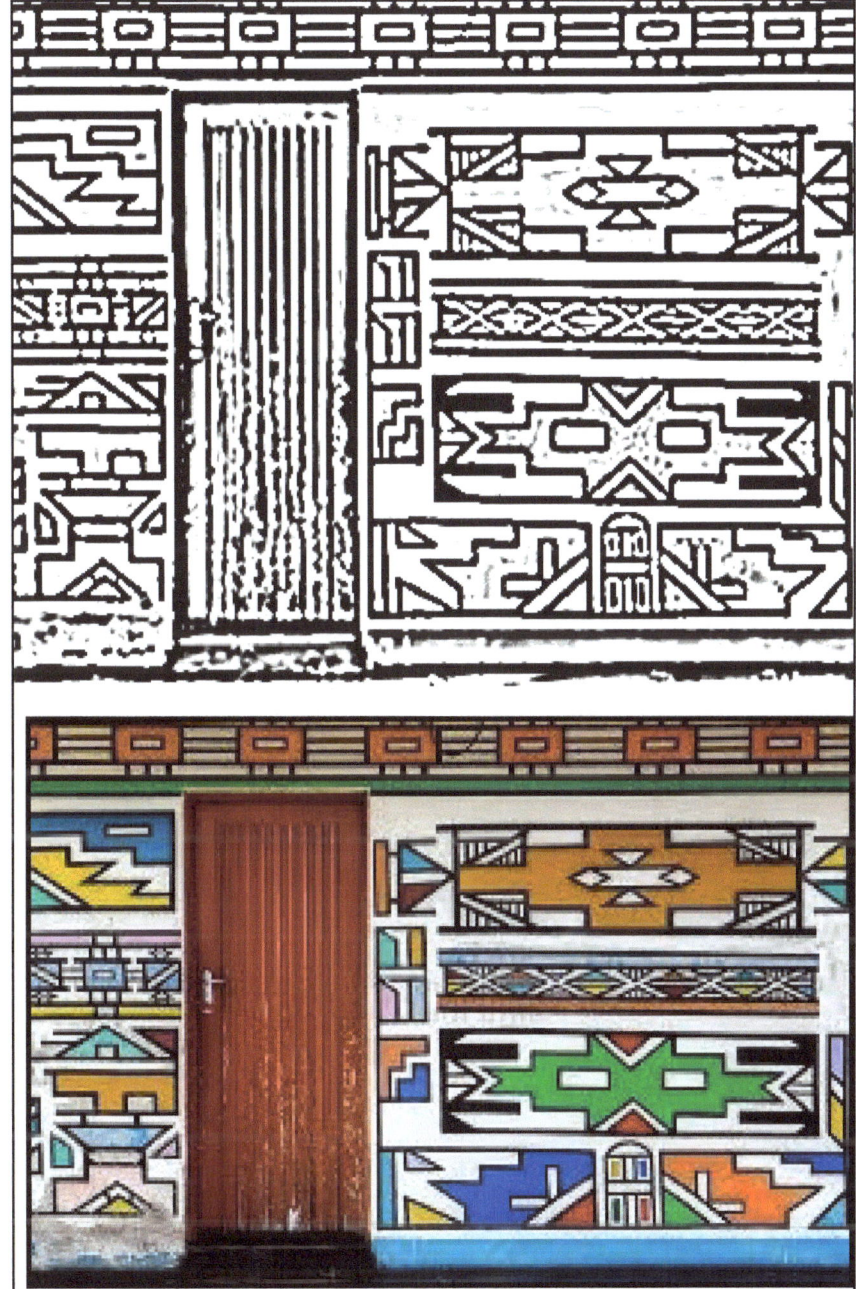

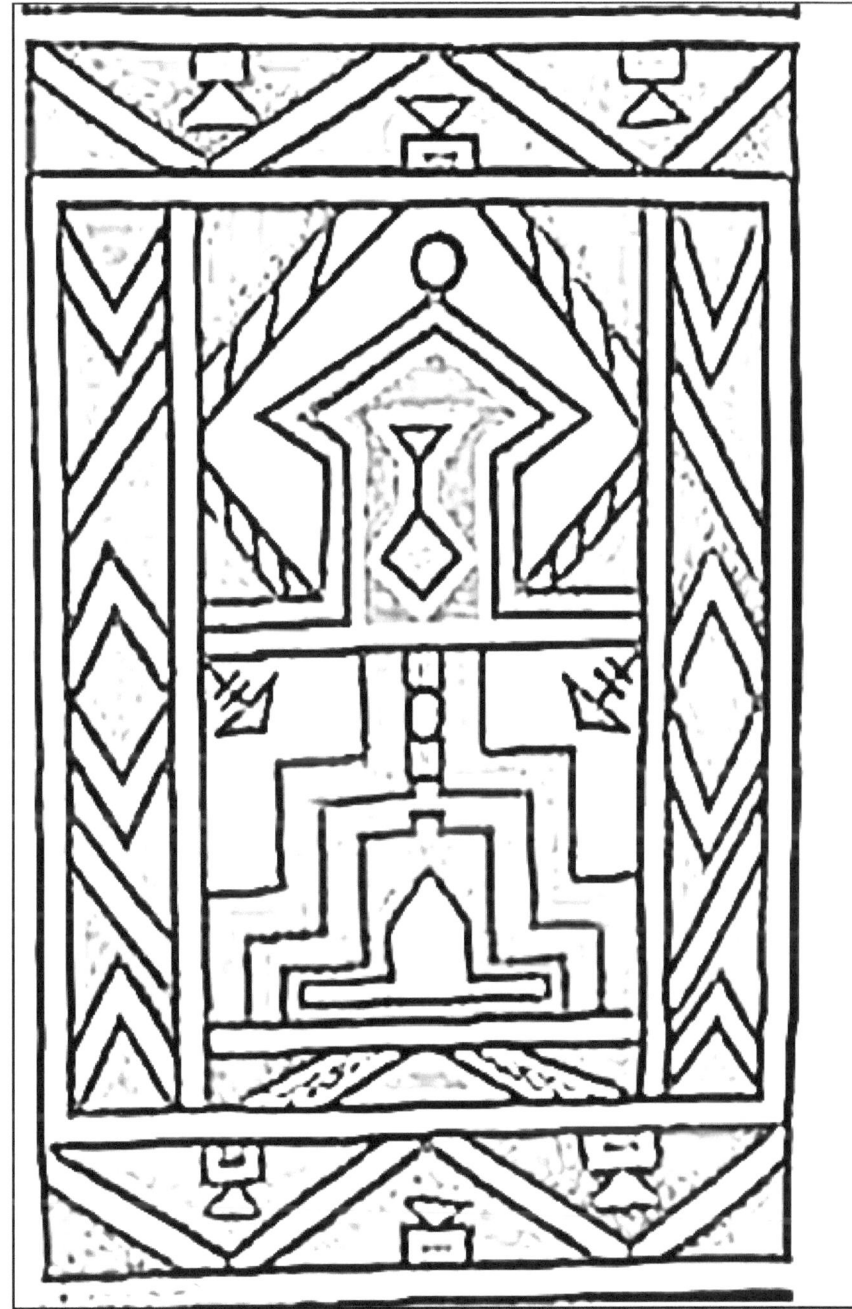

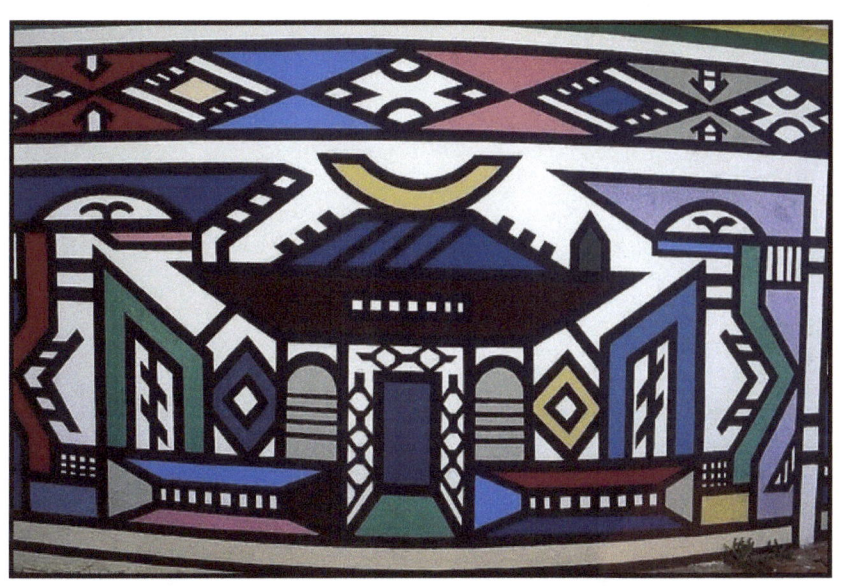

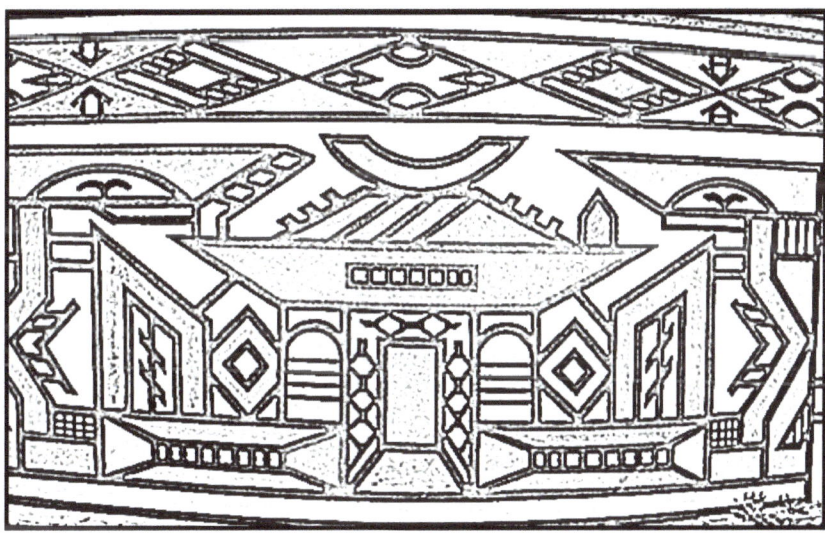

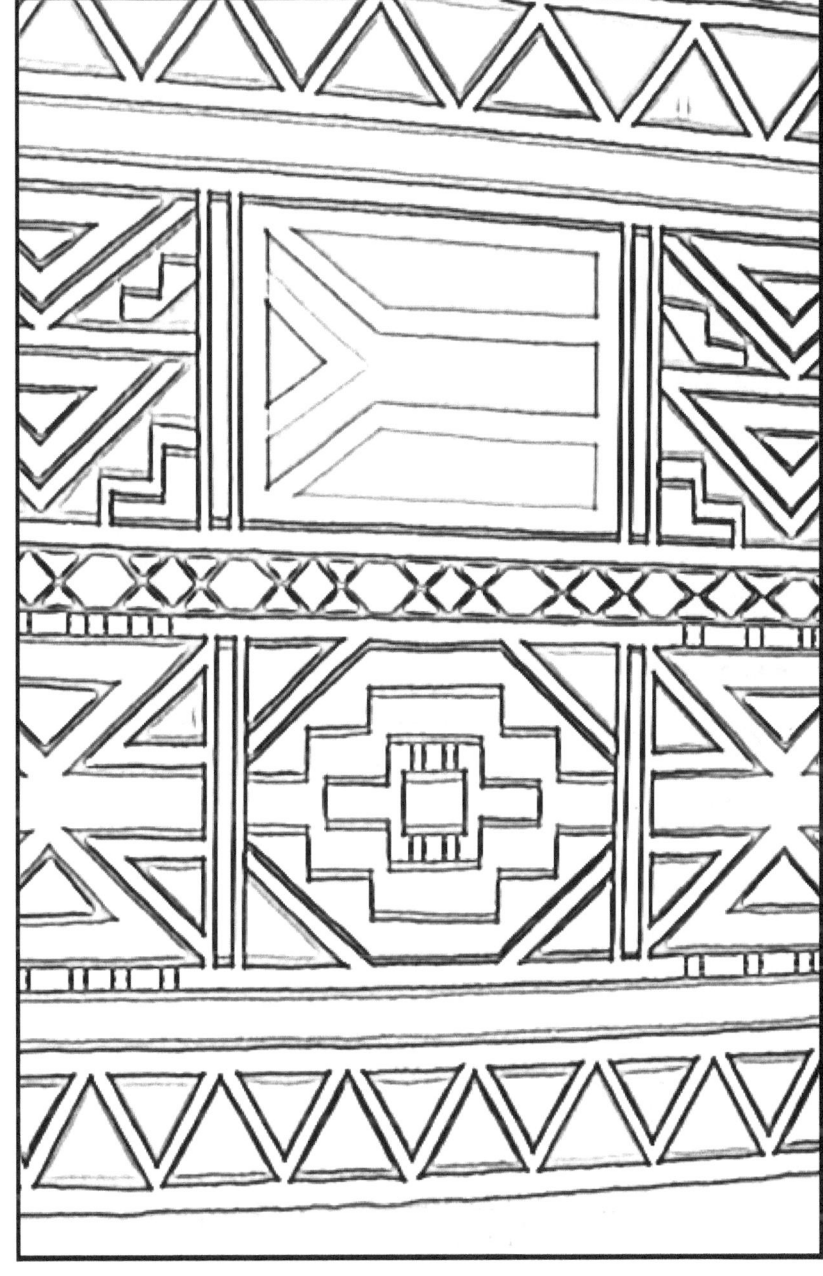

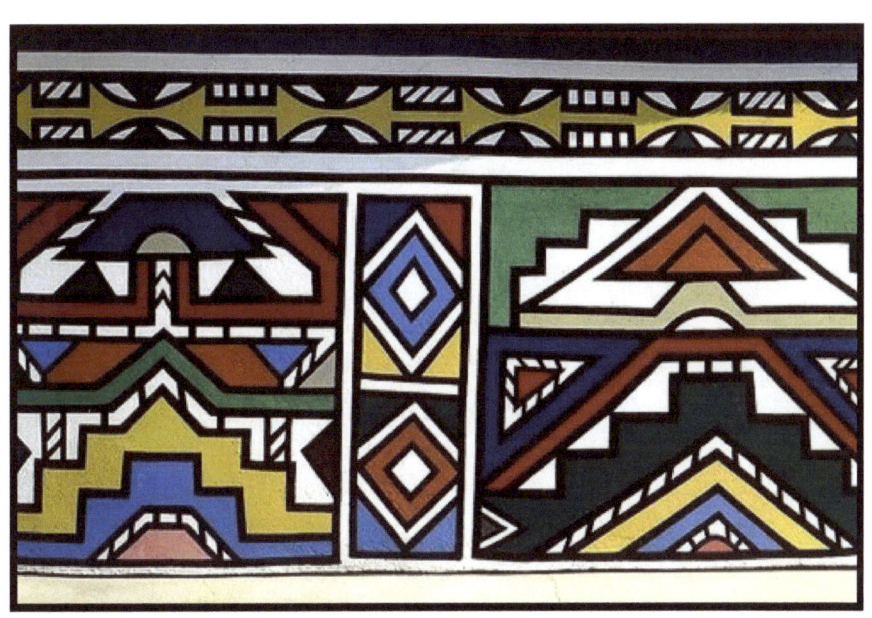
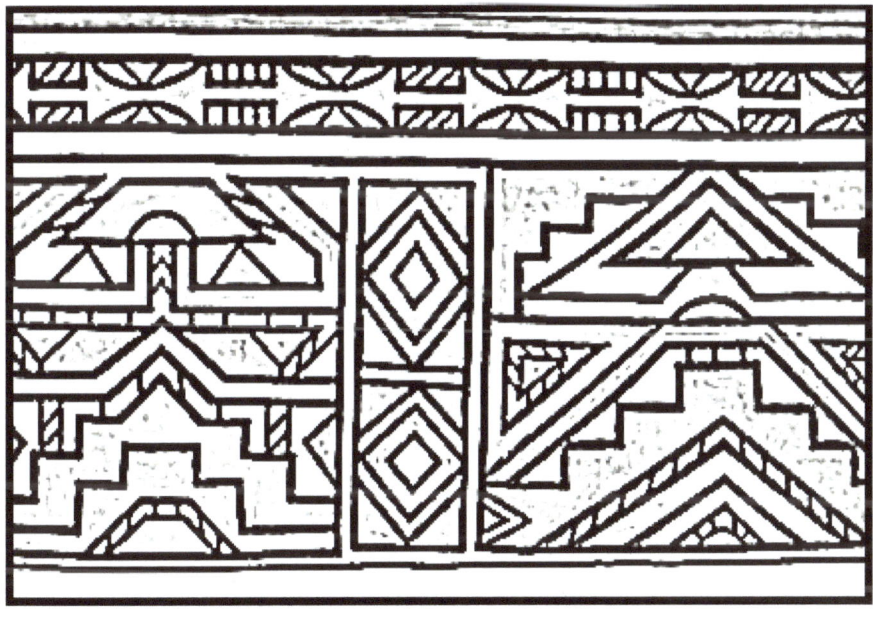

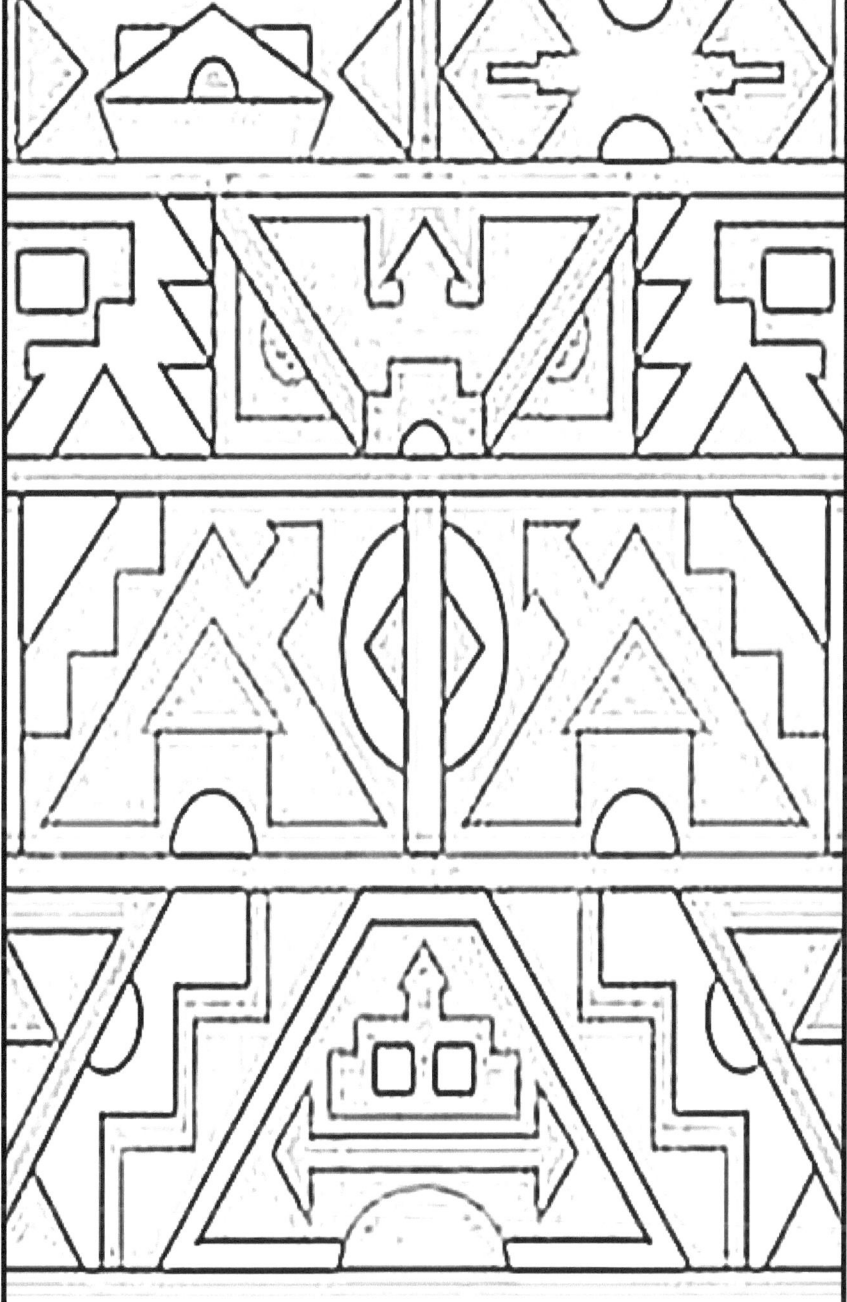

To learn about Ndebele house painting see:
https://en.wikipedia.org/wiki/Litema

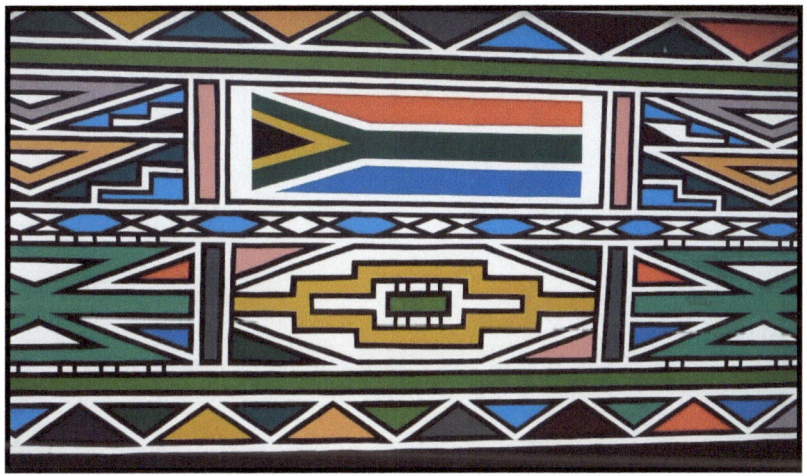

www.ingramcontent.com/pod-product-compliance
Lightning Source LLC
Chambersburg PA
CBHW041619180526
45159CB00002BC/924